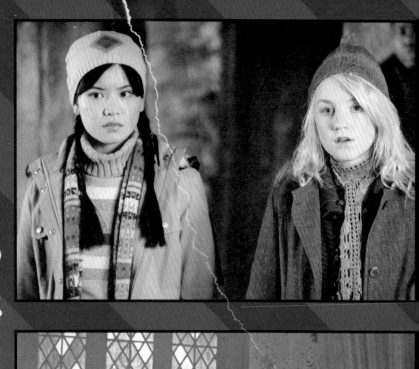
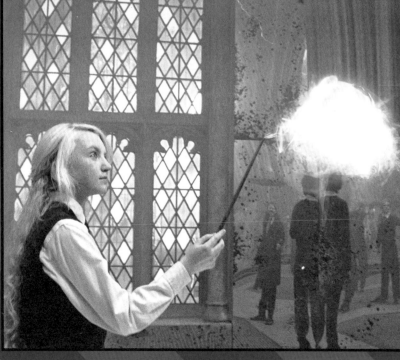

PROPERTY OF

RAVENCLAW™

RAVENCLAW

One of the four houses of Hogwarts School of Witchcraft and Wizardry, Ravenclaw is named after Hogwarts' founder Rowena Ravenclaw. In the films, the Ravenclaw house colors are blue and silver, and a raven adorns its crest.

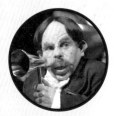

PROFESSOR FILIUS FLITWICK

Head of Ravenclaw house, Professor Flitwick is the Charms teacher at Hogwarts. In the Harry Potter films, he also conducts the Hogwarts choir and the orchestra at the Yule Ball. Professor Flitwick taught Harry, Ron, Hermione, and the other first-years the *Wingardium Leviosa* charm: "Swish and flick!"

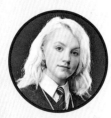

LUNA LOVEGOOD

Nicknamed "Loony Lovegood" by her classmates, Luna Lovegood is considered a bit odd for claiming to see creatures that others can't, such as Nargles and Thestrals. In the film *Harry Potter and the Order of the Phoenix*, she joins Dumbledore's Army and helps Harry and his friends infiltrate the Department of Mysteries at the Ministry of Magic. Her Patronus is a hare.

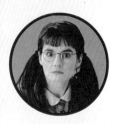

MOANING MYRTLE

In life, Myrtle Warren was a third-year Ravenclaw at Hogwarts. In death, she was renamed Moaning Myrtle, the ghost who haunts the first-floor girls' bathroom. Since she was killed by looking into the eyes of the Basilisk, Myrtle gives Harry and Ron clues that allow them to find the entrance to the Chamber of Secrets. She also helps Harry open the golden egg from the Triwizard Tournament in the film *Harry Potter and the Goblet of Fire*.

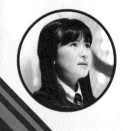

CHO CHANG

During Cho's fifth year, she dated Hogwarts Triwizard champion Cedric Diggory and attended the Yule Ball with him. In *Harry Potter and Order of the Phoenix*, Cho joined Dumbledore's Army and briefly dated Harry Potter.